Ghost Wineries OF NAPA VALLEY

IRENE W. HAYNES

THE WINE APPRECIATION GUILD · SAN FRANCISCO

Published by
The Wine Appreciation Guild Ltd.
155 Connecticut Street
San Francisco, California 94107

(415) 864-1202 FAX: (415) 864-0377

Library of Congress Cataloging-in-publication Data

Haynes, Irene W.
Ghost Wineries of Napa Valley / Irene W. Haynes.
98p. 23cm.
Originally published: San Fransisco: S. Taylor & Friends. c1980.
Includes bibliographical references and index.
ISBN 0-932664-90-3: $8.95
1. Napa River Valley (Calif)--Tours. 2. Wineries--California-
Napa River Valley--Tours. 3. Napa River Valley (Calif.)--Pictoral
works. 4. Wineries--California--Napa River Valley--Pictoral works.
I. Title
F866.N2H39 1994 94-29572
641.2'2'09794419--dc20 CIP

Editor: Sally Taylor

Design by The Digital Table
Ronna Nelson, Lauren Fresk

Printed and bound in the United States

Contents

Introduction

Napa County is dotted with hundreds of picturesque wineries. Millions admire them while tasting the Napa wines whose fame now spreads worldwide. The hundred or more active wineries are identified by names of their entrance signs, but almost a hundred of the most imposing stone or wooden cellars are mysteries because they bear no names.

As an amateur photographer living in the valley, I often wondered about these anonymous ghost wineries. Who built and operated them and when? I tried to re-create in my mind some of the scenes of their long-forgotten past. During the past ten years I have traced their histories, learned who built them, and found that these ghosts of the bygone century were the pioneers of Napa wines' greatness of today.

Many of my friends have expressed interest in the ghost wineries and have persuaded me to assemble their stories with my photographs in a book. I have grouped them into convenient motoring tours of the county, with maps showing the location of each, in relation to some of the newer wineries which serve as helpful guideposts along each route.

Irene Haynes
August 1995
Calistoga, California

Many of the old ghosts along this tour are now private homes. Please respect their privacy.

St. Helena

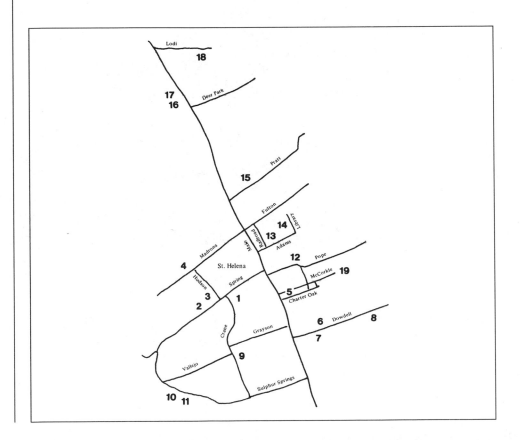

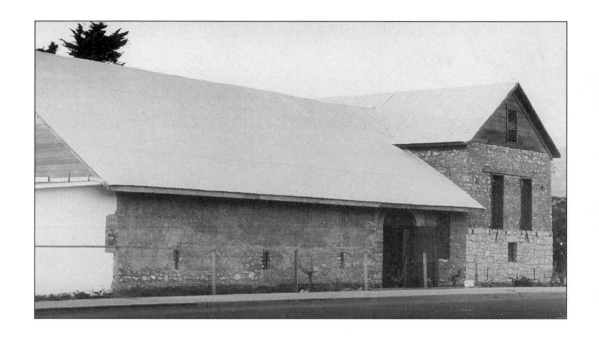

Within a forty-block area of St. Helena you will find fifteen of the ghosts. On the south side of Spring Street, three blocks from Main Street (Highway 29), is the Lewelling Winery, erected by North Carolinian John Lewelling before 1876. The green stucco with which later proprietors (Rossi, Poggi, Refigo, Muther) plastered the exterior has been peeled away, revealing the rough hand-hewn fieldstone of which the original portion was built by the pioneer Lewelling more than a century ago. Several years ago it was converted into a handsome residence.

1

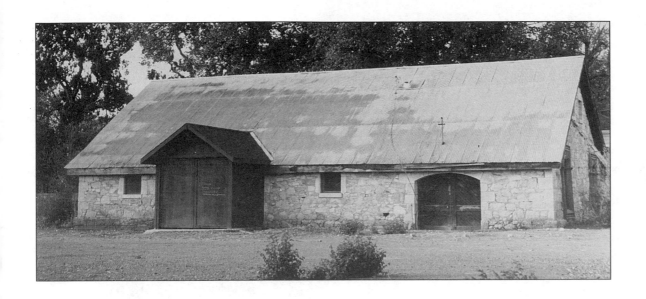

Two blocks west, a hundred yards past the northwest corner of Hudson Avenue, is the stone Esmeralda Winery, which German-born George Schoenwald erected in the 1890s to make wine for San Francisco's Palace Hotel. Subsequent owners changed the name to Bellani, and after Repeal to Montebello, a company which in the 1950s produced wines for the Renault vintners of New Jersey. It is now an attractive home.

3

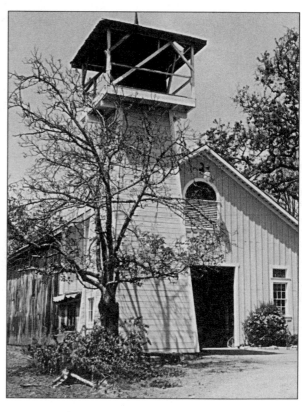

2 | A block farther west on Spring Street, the ancient barnlike structure you see on your right was once the Tosetti Winery. It dates from 1882 when Baldisere Tosetti from Italy built the cellar to make wine, which he sold in jugs and barrels at the cellar door. Across the street there stood in the 1880s the Schulze or Schultz Winery, which burned to the ground in 1908.

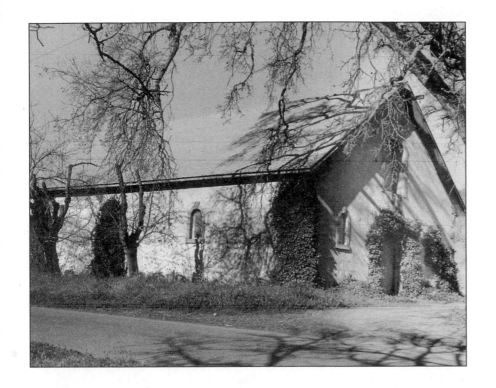

St. Helena Star
September 23, 1887

*Everywhere we went we learned
of a scarcity of labor, both in cellars
and vineyards. In many vineyards
we found women and children at work
picking grapes and earning good wages.
White men were paid $2.00 a day.
Chinamen about $1.25, some
were demanding $1.50.*

Three blocks north on Hudson Avenue and a left turn onto Madrona brings you to a venerable sandstone ghost winery, with arched, ornamental windows, on your right. It was the Kraft Winery, operated by Frank Kraft from 1884 until the late 1890s. Mary Novak, the present owner of the winery, has restored it to operating condition and plans to reactivate it soon.

4

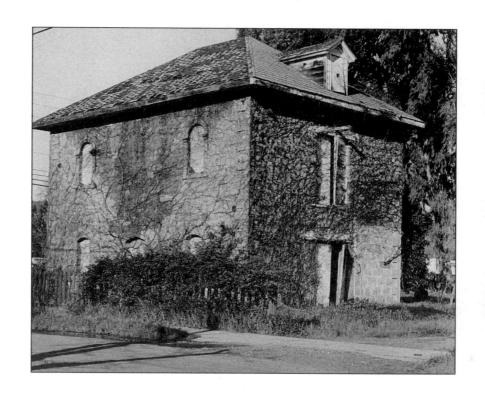

South of downtown St. Helena, that interesting-looking two-story antique stone cellar on the northeast corner of Main Street and Charter Oak Avenue, much admired and photographed by tourists, was a different kind of winery. Frank Sciaroni from Switzerland built it in 1880 as his "sherry house" - a cellar where white wine was heated, literally baked - to become sherry. Adjoining were Sciaroni's winery and brandy distillery, since replaced by a restaurant complex.

5

At the end of McCorkle Avenue, which extends north from the east end of Charter Oak Avenue, are the ghost remains of the stone David Cole Winery, which produced wine from 1884 to the early 1900s. All that are left are the two-foot-thick walls with the arched door and windows. Now the roofed-over ruin is used by Oswald Particelli to store supplies for his Olive Oil Factory nearby.

19

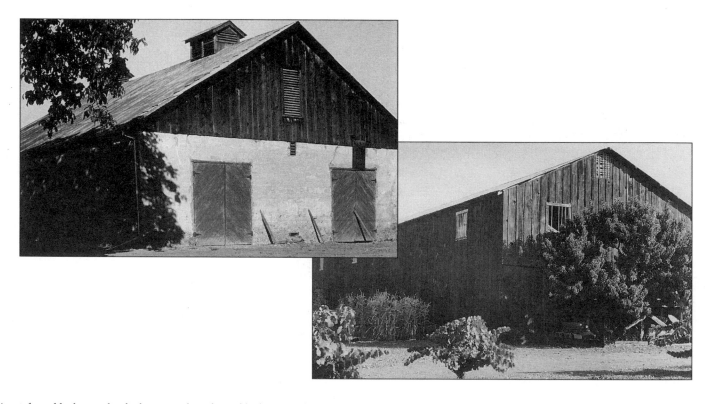

6 | Three blocks south of Charter Oak and two blocks east of Main Street is the Fountain Winery on the north side of Dowdell Lane. The
lower part is of stone, the upper of wood. It dates from 1876 when George Fountain, from New York State, began making wine there; he
7 | continued until 1911. In the larger wooden structure across the street, William Bornhorst and William Ebeling from Germany made wine
from 1909 until Prohibition. It briefly housed a fruit distillery after Repeal. The Fountain Winery was demolished in the early 1990s.

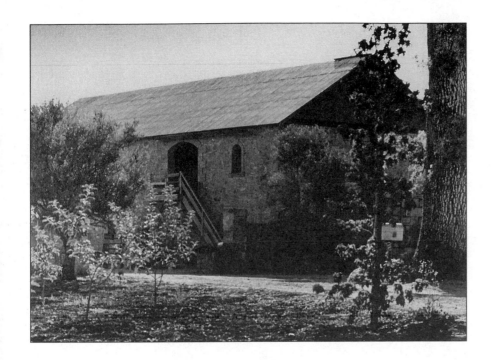

St. Helena Star
October 27, 1884

H. A. Pellet, the old and well-known winemaker, and a pioneer in this business, is to the front as usual with a cellar full of good wine, and for a wonder is selling grapes to others, for the very simple reason that his vineyard has unexpectedly far exceeded the capacity of the cellar…His land yielded 8 to 11 tons per acre, which considering its light and dry character, is remarkable…Needless to say his vintage is all in good condition and will add wealth to its owner while he looks out for vinicultural interests in the coming session of the State Legislature.

The handsome three-story stone residence near the east end of the street was built as a winery in 1886 by James Dowdell, who came from Ireland by way of New Zealand and became foreman at the Edge Hill Winery before building his own here. Charles Crocker of the San Francisco banking family was a recent owner.

8

St. Helena Star
September 23, 1887

W. B. Bourn has a part of Krug Cellar rented and has H. A. Pellet again in charge of the winemaking; when we went there yesterday we found nearly 20 loaded grape wagons drawn up in line waiting for a chance to weigh and unload...Pellet says there is too much sugar; says the white grapes will go through all right, but the red grapes will be a "holy terror" (not his exact language, but winemakers will know what he said).

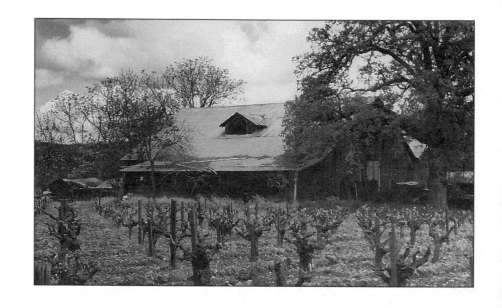

To the west of Main Street, opposite Dowdell Lane, there were several wineries as early as the 1860s. Where St. Helena High School now stands was the great vineyard and winery of scholarly physician George Belden Crane, who emigrated to Napa Valley from New York in 1857. Some of his wines were shipped around Cape Horn to New York. Immediately west of Dr. Crane's winery stood that of Pellet and Carver. Still farther west was the winery of Mrs. William Bowen Bourn, whose son later built the Greystone Winery at the north edge of St. Helena. Nearby, at the west end of Grayson Avenue, is a youngish ghost winery, Sunnybrook, which operated from Repeal in 1933 until 1947.

9

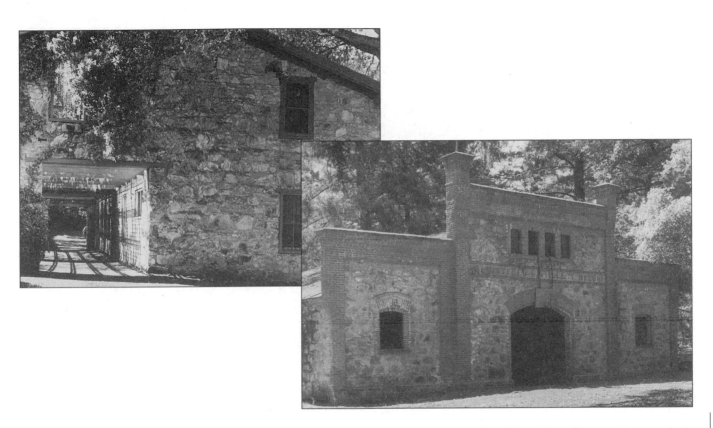

At the west end of Sulphur Springs Avenue, but inaccessible to sightseers, is the great stone cellar of the Edge Hill Vineyard winery, built in 1870 by Indian-fighter General Erasmus D. Keyes. It is now the residence of well-known winegrower Louis P. Martini. Nearby is the empty stone brandy distillery, numbered "Registered Distillery 209."

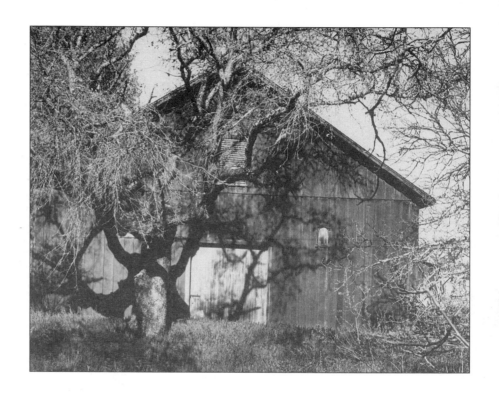

12 On Pope Street, which extends east from Main, stands the winery built in 1880 by General Jacob Meiley. You see it just before the bridge across Sulphur Springs Creek. No trace remains of the Leuthold winery, its one-time neighbor across the creek; Leuthold produced 12,000 gallons in 1884.

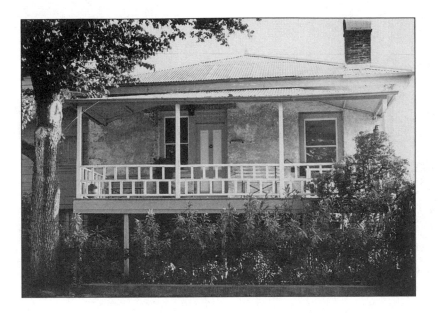

Napa Daily Register
February 21, 1880

John Ramos has bought of William Fealy, for $4,000, the latter's place of 9 acres in St. Helena, and will turn it into grape-bearing and wine-producing establishment. Mr. Ramos' specialty is making sherry wine, by the heating process, being trained to that in the Madeira Islands, and having, with Frank Sciaroni, conducted the manufacture of that article in Dr. Crane's sherry house ever since its building. In pursuance of this specialty he will erect a sherry house on his new purchase, by the railroad track, and for this purpose is getting out stone. It will be 25x32 and capable of holding 28,000 gallons of wine.

Fulton Lane, five blocks north of Pope Street, was named for David Fulton, whose winery on the lane was built in the 1860s; it long since has disappeared. Around the corner on Railroad Avenue, across from Lyman Park, stands a stone-walled building that was built a century age as a "sherry house" to bake surplus wine of Mission grapes into Napa Valley Sherry. John Ramos, its builder, brought the estufa or oven method of baking sherry or madeira from the Island of Madeira, where he was born. He made his first Napa Sherry at Dr. Crane's winery, mentioned earlier. He then erected his own "sherry house" here in 1880-81. The adjoining wooden building, a saloon and bordello, was subsequently joined to the sherry house. In 1962 it was converted into a residence by former Mills College Dean Esther Waite. It later was converted into offices and shops.

13

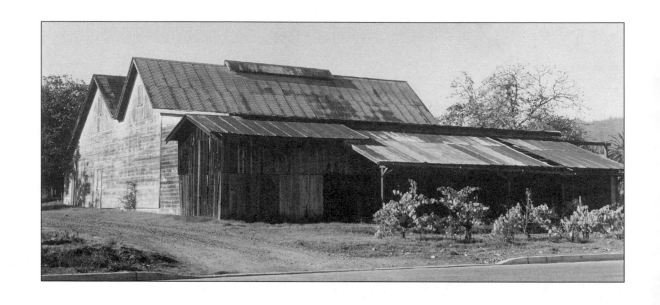

14 | The weather-beaten wooden structure on Library Lane across from the public library was once the Jackse Winery, built by Stephen Jackse from Austria about 1910. It was revived at the end of Prohibition but was closed by his son in 1951.

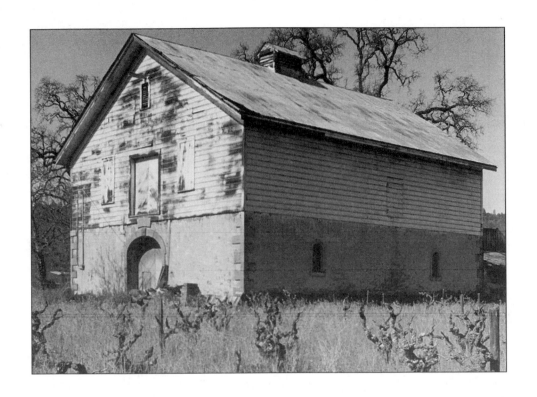

There is an empty ghost off the north side of Pratt Avenue, a half mile east of Main Street. It is the one-time Zange Winery, built of wood and stone by Emil Zange in 1891. Closed by Prohibition, it operated again from Repeal until 1951.

15



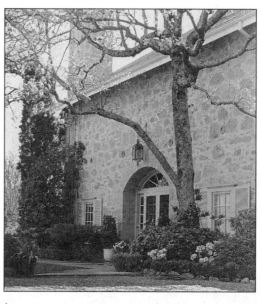

Bordering the highway at the north end of St. Helena are four of the oldest pre-Prohibition wineries, more active today than at any time in the past. On the west side is the original Beringer Cellar, which has never been closed since it was built in 1876; it produced sacramental wine with government permission during the thirteen Prohibition years. A modern new Beringer winery was built across the road in 1975; the original cellar and the adjoining Rhine House are now used mainly to receive visitors. Next on the west side is the prodigious stone Greystone cellar, erected by William Bourn II and Everett Wise in 1889 to age surplus Napa wine in its cavernous tunnels; owned and operated for years by the Christian Brothers, it is now being converted into a culinary arts academy. On the east side of the highway, adjoining the shiny new Beringer winery, is the Charles Krug Winery, whose owners have preserved one stone wall of the original building that was erected in 1861. A half mile north of Krug is the newly refurbished Markham Winery, which was erected around a cellar built in 1877 by Jean Laurent from France.

16

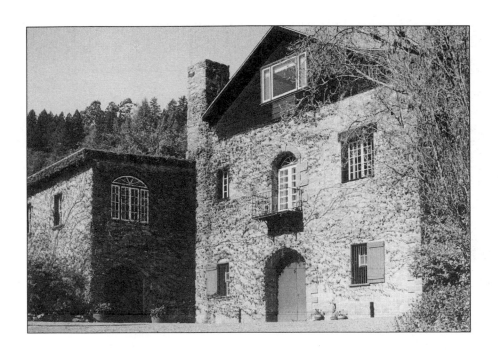

An unmarked road on the west side of Highway 29, south of Lodi Lane, leads to two century-old wineries that have been converted into handsome homes. The one at your left was built by winegrower William Castner in 1880 with a wine-aging tunnel dug into the hillside. The other was erected in 1876 by John C. Weinberger, an emigre winegrower from Bavaria.

17

E. M. York has an immense crop of his own grapes - 230 to 300 tons - and was absent, getting more help to pick them, at the time of our visit. His young son informs us that some of his vineyards yielded as high as twenty tons per acre.

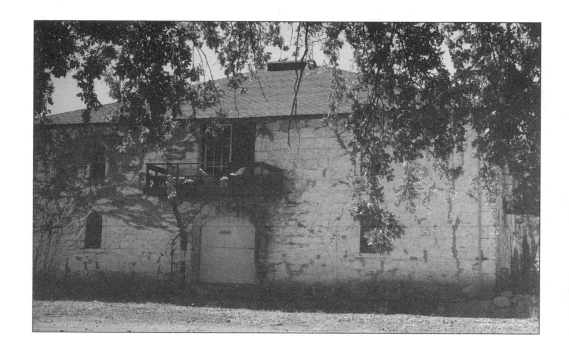

18

The two-story stone cellar at 1095 Lodi Lane was founded as the York Winery in 1880 by Eli McLane York. York's nearby vineyards died in the phylloxera epidemic at the turn of the century. His grandchildren then used the upper story of the winery as a skating rink and the lower as their stable. The building was severely damaged by the San Francisco, Loma Prieta earthquake of October 10, 1989. It underwent extensive reconstruction.

Elhers Lane North

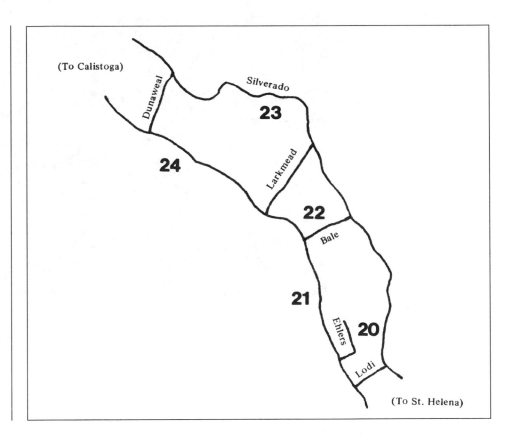

(To Calistoga)

Dunaweal

Silverado

23

Larkmead

24

22

Bale

21

Ehlers

20

Lodi

(To St. Helena)

Chapter 2

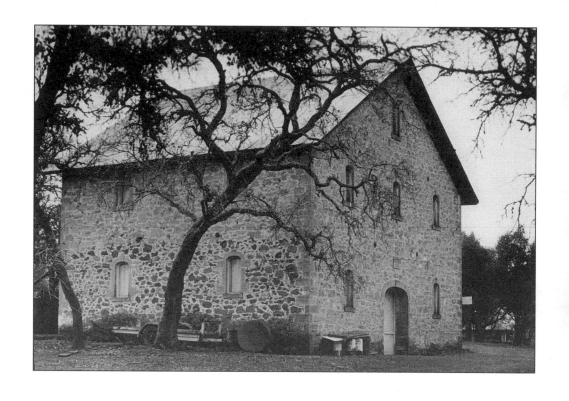

20 | Ehlers Lane, a half mile north of Freemark Abbey, commemorates a Napa winegrower from Germany whose given name nobody remembers. "B. Ehlers" and "1886" are inscribed in the face of the buff-colored two-story edifice. It was idle during Prohibition but has been occupied by other producers since Repeal.

St. Helena Star
October 27, 1884

At Mr. Lyman's we were not so fortunate as to find that gentleman at home, and the winemaker in charge, Mr. Carl Metzger, speaks so little English as to but imperfectly understand our desires. We gather that the season's yield will be about 14,000 gallons, and that Mr. Lyman uses only his own grapes. His product last year was 12,000 gallons.

A handsome stone cellar (now owned by New York financier Reginald Oliver) on Lyman Canyon Road, a half mile farther north on the left, was built in 1871 by Colonel W. W. Lyman. He named it El Molino Winery, Spanish for "the mill," for the old Bale Mill which is now part of the nearby state park. The two-foot thickness of its walls is evident. My photograph was taken before a fire; it has since been rebuilt. Colonel Lyman produced superior wines and aged them in tunnels cut into the hillside behind the cellar, until phylloxera destroyed his vineyards about 1915. Mr. Oliver has enlarged the tunnels and by ingenious use of space behind the old cellar (now a handsome residence) has created a splendid modern cellar.

21

22 | On the north side of Bale Lane between Highway 29 and Silverado Trail is Bartolomeo Caramella's second winery. (You will find his first mentioned later in Chapter 4.) A barn-like wooden structure built in the 1890s, it was closed by Prohibition and its wine had turned to vinegar by the time it was opened at Repeal. Wine was never made there again.

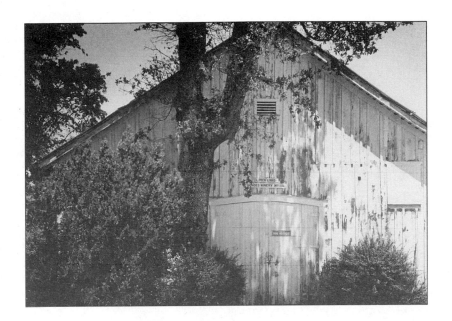

Larkmead Lane, two roads to the right, leads eastward to the Hanns Kornell Champagne Cellars. The central stone building was erected by the Salmina family from Switzerland in the 1880s on land owned by Lillie Hitchcock Coit. Later proprietors included National Distillers, Bruno Solari, and the Larkmead growers' cooperative, until Hanns Kornell from Germany took over in 1958.

Soon after leaving Larkmead Lane, you will see a cluster of white buildings in the distance on your right, reached via private road. One of them is the winery established in 1912 by Libero Pocai from Italy. He and his sons made wine in bulk for other wineries for many years, but also bottled some, which won prizes at the State Fair. As you glimpse the Sterling winery on the hill to the right, a small wooden sign points to the left, with the legend "Heitz Way." It commemorates the small stone winery built there by Michael Heitz in 1904. It operated until the Dry era began in 1920.

23
24

Around Calistoga

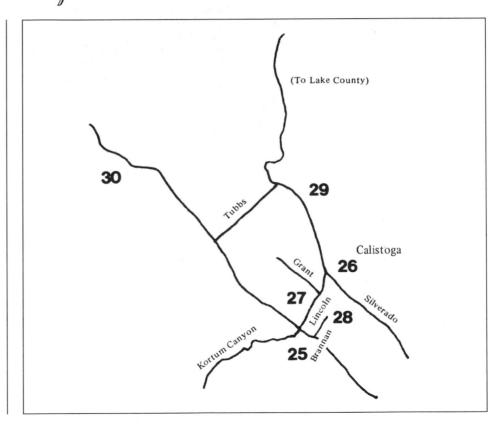

(To Lake County)

30

29

Tubbs

Calistoga

Grant

26

27

Silverado

Lincoln

28

Kortum Canyon

Brannan

25

Chapter 3

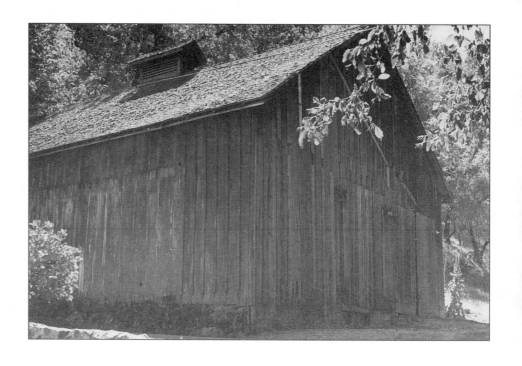

Highway 29 reaches Calistoga at a traffic light and continues north as Foothill Boulevard (Highway 128). Kortum Canyon Road extends left at the light, and there, not far from the intersection, is the ghost of Calistoga's oldest large pre-Prohibition winery, built by German emigre Louis Kortum. Famous for its horse-powered grape crusher, it was described by a valley newspaper in 1884: "From morning until night, wagons loaded with grapes stand waiting in line at Kortum's Wine Cellar and so fast as one load is disposed of, another is drawn onto the scales." Closed by Prohibition, the Kortum Wine Cellar did not open following Repeal.

25

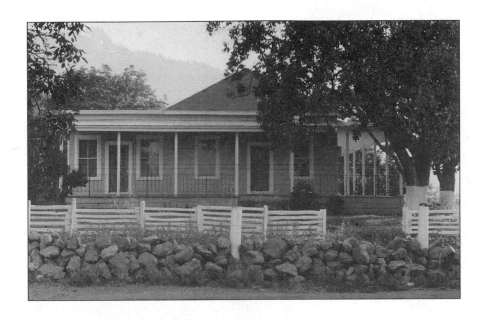

In Calistoga, known for its mineral spas, I long searched for traces of fabulous Samuel Brannan's winery and brandy distillery. Brannan, the one-time Mormon leader and California's first millionaire who founded and named Calistoga in 1859, was reputed to own 2,000 acres and to have planted vines that he personally brought from Europe. All I have found and pictured here is this wooden cottage on the east side of Silverado Trail a half block south of Lincoln Avenue. The only evidence of its wine-cellar past is that its walls contain a 14-inch thickness of sawdust, presumably insulation to keep Brannan's wines cool. Adding uncertainty to my search is the fact that this was not the structure's original location, that it was moved here from an earlier site. Calistoga contains little else to commemorate its founder: a street named Brannan, a plaque beside a bath house, a small, fading building on Wapoo Avenue that once was his store, and this cottage, his purported winery.

26

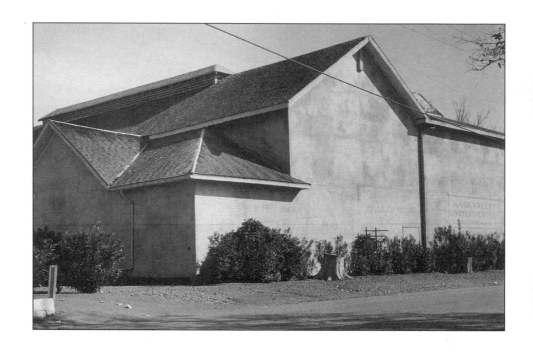

At Grant and Stevenson Streets in Calistoga is a two-story stuccoed building that was Brannan's stable until he abandoned all his property following his divorce in the 1870s. Ephraim Light from Pennsylvania later turned the stable into a winery, which he operated until Prohibition. It apparently was Light who moved the cottage that is purported to be Brannan's wine cellar, and Light lived in it for many years. At Repeal in 1933, Charles Forni and Adam Bianchi reopened the former Light Winery as the Napa Valley Co-operative Winery, joined the Fruit Industries, the national co-op marketing concern, and made wine in the building until the co-op moved to its present location at the southern outskirts of St. Helena.

27

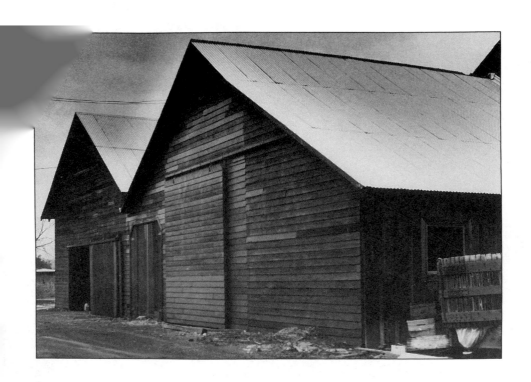

There were many more wineries around Calistoga before Prohibition. Three of them still stand as ghosts. One is the Ghisolfo or Calistoga Wine Company, which occupied the wooden buildings on the west side of Silverado Trail south of Brannan Street. The company made wine from 1906 to Prohibition and from Repeal to 1950.

2

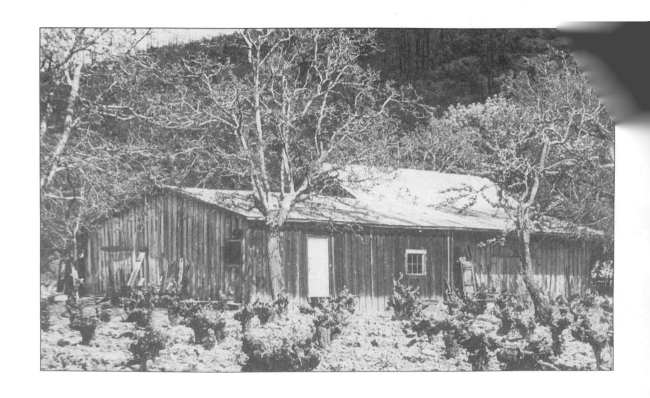

29 | Another is the wooden cellar Domenico Barberis built in 1915 on the north side of Palisades Road, close to the base of the eastern hills.

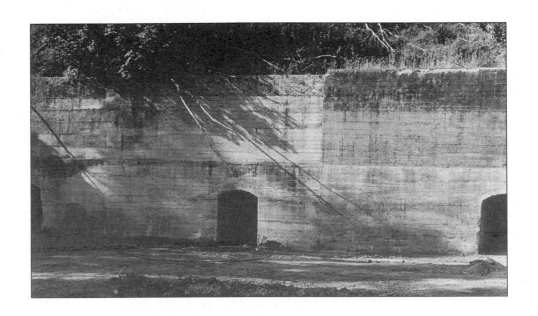

The third ghost, more prestigious, is the trio of deep hillside wineaging tunnels hidden behind a locked gate on the south side of Highway 128, four miles northwest of Calistoga. They are all that remain of the winery and distillery founded in 1888 by the uncles of the gentleman farmer from San Francisco, Jacob Grimm. The tunnels, among the best preserved in California, have inspired the property's present owners, Jerry and Sigrid Seps, to establish their Storybook Mountain Winery in the famous tunnels. Crushing is done outside and the storage tanks stand outside where the Grimm Winery once stood.

There were many more wineries around Calistoga before Prohibition, with such names as J. H. H. Medeau, John Schleicher, Achilles Banchieri, Lorenz Petersen, Louis Nolasco, Robert Walsh, Pickett (for whom Pickett Lane was named), Dean Tucker, Edward Doda, and Hiltel.

Along Silverado Trail

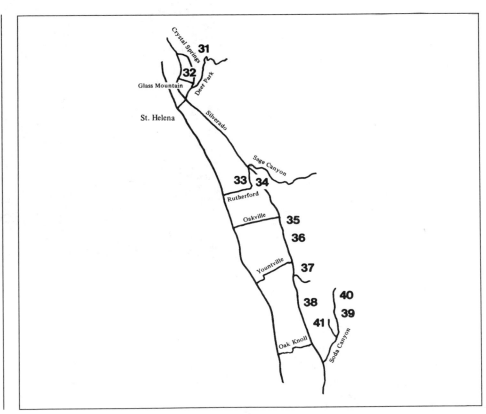

Chapter 4

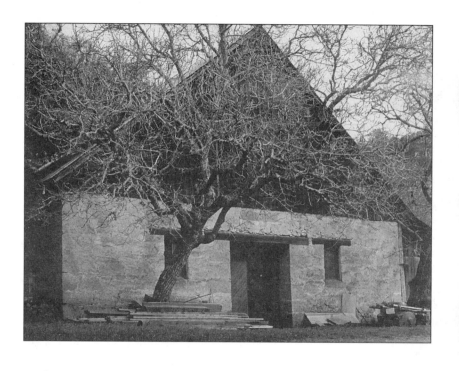

Leaving Calistoga on Silverado Trail, a mile or two past the new Cuvaison Winery, Crystal Springs Road leads eastward. A mile up the road on your left is the small stone winery that Carlo Rossini from Switzerland built in the 1880s and operated until Prohibition. His granddaughter, Marielouise Rossini Kornell, recalls how Rossini celebrated the Fourth of July with feasting, a barbecue, music, dancing, and fireworks to honor the birthday of his adopted country.

Across the road from the Rossini winery is part of the stone wall of the first Caramella Winery, which was built in the 1870s. He abandoned it when he built the cellar on Bale Lane. (See Chapter 1.)

31

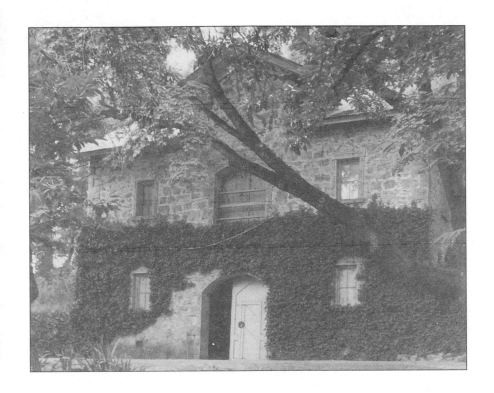

From Glass Mountain Road, the next on your left, a private road leads left for three-fourths of a mile to a stately two-story stone cellar that bears the date "1881." This was the Villa Remi Winery, a hobby of Remi Chabot, one of the brothers who built the Chabot Observatory and left their names on such East Bay landmarks as Chabot College and Lake Chabot. Prohibition put an end to his wine-making, and the cellar has since been for storage.

St. Helena Star
October 23, 1884

"Chris" Adamson's fine new cellar...being so large in a neighborhood where heretofore there was none, it seems as though it must incontinently swallow up all the grapes of the country roundabout. But, strange to say, it has not; and not only that, it actually is not big enough for the situation, lots of Chris' own grapes being still out from want of present room in the cellar and its caskage to store them. His own grapes have been over 300 tons, and his wine product is about 90,000 gallons. He will have to build more rooms next year or stop buying grapes, his own crop promising to fill it all up another season.

Five miles south of Glass Mountain Road, Highway 128 toward Rutherford leads south toward two century-old wineries. The venerable wooden cellar on you right, painted red, was the winery of Holsteinborn Christian P. Adamson. It operated until phylloxera destroyed his vineyards. It is now used again for the aging of wines.

33

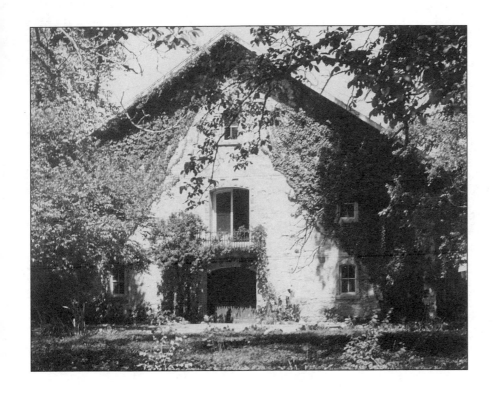

St. Helena Star

September 23, 1887

We were fortunate to find the genial sheriff of Napa County "at home" on his fine ranch near Rutherford and accepted with alacrity his invitation to inspect his magnificent new stone cellar...It is of solid stone, two stories high and 60 x 120 feet in size. Mr. Harris will have 300 tons of his own grapes and takes a few from his neighbors...He expects to make 80,000 to 100,000 gallons of wine.

Directly across the road from the Adamson cellar is the two-story stone winery built in 1886 by then Napa County Sheriff Henry H. Harris, who operated it until Prohibition. After Repeal it was purchased by Mrs. Louis de Laveaga Cebrian of San Francisco and became her weekend home, renamed Puerto Dorada.

34

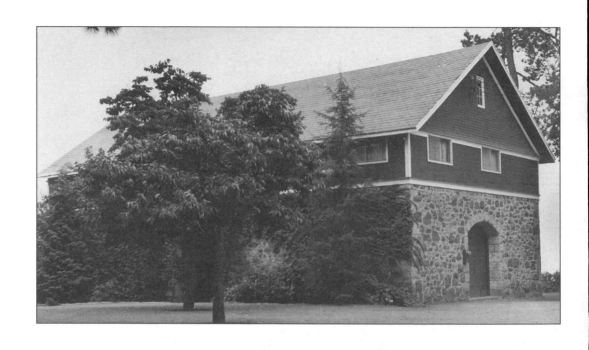

Returning to Silverado Trail and continuing south two and a half miles, you may find a private driveway between stone pillars at your left. It leads uphill almost two miles (right at the first "Y", left at the second; a difficult drive) to another handsome pre-Prohibition winery converted into the William McPherson residence. This was the cellar that San Francisco cafe-owner Benjamin F. Jellison built in 1911, replacing a smaller one built in 1909 that became a distillery. He is said to have commuted weekly to his business by surrey, train, and the Vallejo ferryboat to San Francisco.

35

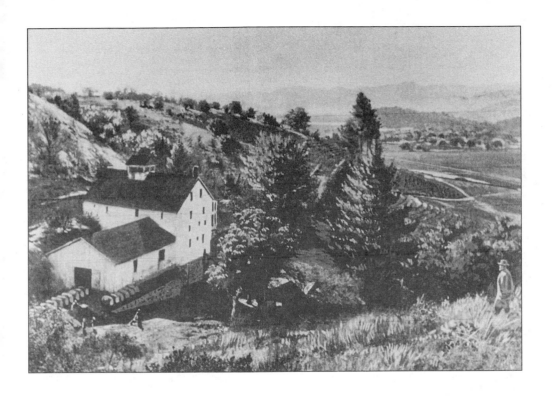

Among the rocks below Rector Dam, which is visible east of Silverado Trail three miles north of Yountville, there stood, from the 1870s until the late 1890s, the elegant four-story Vine Cliff Winery of Burrage & Tucker, its cellars built as tunnels into the cliff. For many years it was owned by Colonel Joseph Fry, a son-in-law of the legendary San Francisco financier William C. Ralston. The vineyard succumbed to the phylloxera scourge and the depression of the 1890s, and nothing remains of the winery.

36

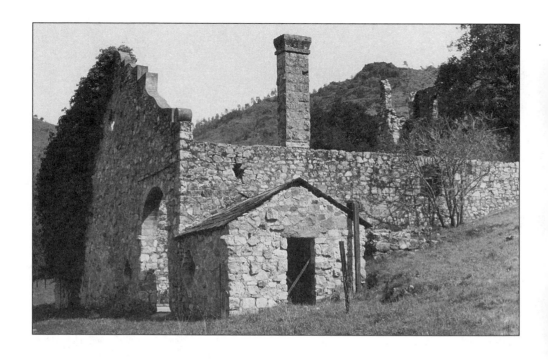

The next ghost winery on this route is at Stag's Leap, a rocky promontory overlooking a vineyard valley east of Silverado Trail. It is reached by an unmarked road to the east, three-fifths of a mile south of Yountville Crossroad. Chicago financier Horace Chase is said to have named the promontory for a legendary stag when in 1888 he built his winery and the residence that later became the Stag's Leap Hotel. Chase later lost his fortune and neglected the stone winery. Karl Doumani bought the property in the 1970s. When he restored the historic ruin he used three walls of the original cellar. It is once again an operating winery. (It is not to be confused with the famous Stag's Leap Wine Cellars of Warren and Barbara Winiarski, a modern winery built in 1972 bordering Silverado Trail several hundred yards away.)

37

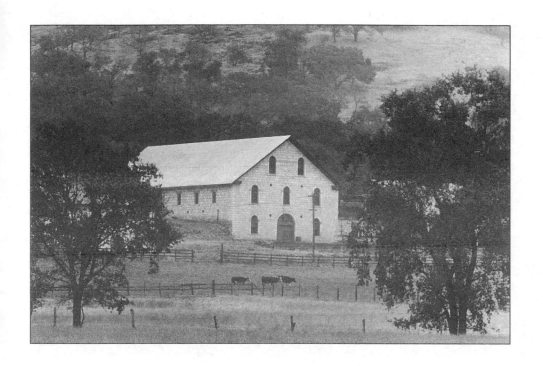

South of Stag's Leap, there is visible to the east one of the handsomest ghost wineries in the county, the three-story Occidental cellar, built in 1878 by Terrill L. Grigsby, a pioneer who came to California by oxcart in 1850 and helped raise the Bear Flag over Sonoma Plaza when California declared its independence from Mexico in 1846. Its hand-cut stone facade, arched windows, and two-foot-thick walls are of lava stone, soft enough when first quarried to be cut with an axe or saw. The old cellar is now used by nearby Clos du Val Winery to store its library of wines.

38

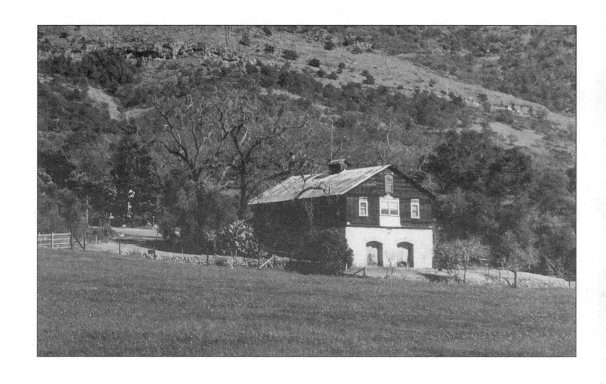

39 | The next turnoff on the left is Soda Canyon Road, which leads to ghosts of three pre-Prohibition wineries. On the hillside three miles ahead on your right is an imposing two-story wood and stone cellar turned into a residence of John Soracco. It was built in 1888 by Felix Borreo from Genoa as his Bay View Ranch and Vineyard winery. Wine was made there until Prohibition.

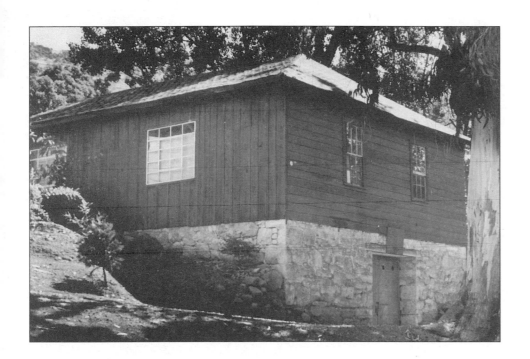

Next, less than a mile ahead on the right, is a small two-story stone and wood cellar. Luigi Banchero, Italian born, built it in the late 1890s and made wine there until Prohibition. His son Louis reopened it at Repeal and made wine until 1942.

Loma Vista Drive takes off north from Soda Canyon Road to an attractive stone residence on your left. It originally was Dr. John A. Pettingill's White Rock Winery, built in 1870 of stone quarried on his farm. It has been remodeled extensively, but portions of Dr. Pettingill's construction remain.

40

41

Conn Valley

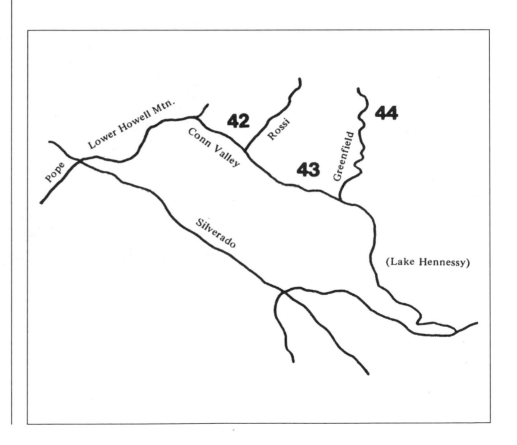

Lower Howell Mtn.

Pope

Conn Valley

42

Rossi

44

43

Greenfield

Silverado

(Lake Hennessy)

Chapter 5

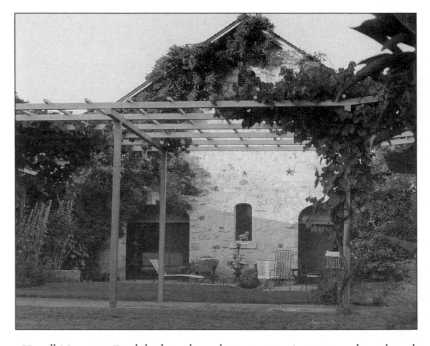

Conn Valley Road, which extends southeast from lower Howell Mountain Road, leads to three ghost wineries. A private road a mile and a half from the intersection leads across a creek to a lovely stone residence that, starting in the 1880s, was the Mountain Cove Ranch winery of Abran Alsip. A former Marylander who crossed the plains by oxcart in 1853, Alsip made fine wines, but grieved because wine merchants in the 1880s sold them under counterfeit names. "When our wines can hold under home labels the high reputation they now enjoy under foreign labels," he wrote, "the difficulties of the wine business will have been solved." His vineyard was destroyed by the phylloxera vine louse around the turn of the century, and the winery was closed. During the 1950s retired Harvard Professor Francis Wayne MacVeagh and his wife converted the winery into their home.

42

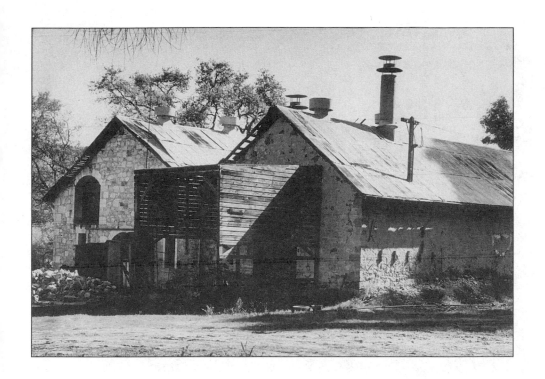

A mile farther on the left is the neglected ghost of G. Crochat and Company's Franco-Swiss winery, a pair of stone cellars that housed one of Napa's County's largest pre-Prohibition wineries. Franco-Swiss wines were being exported to foreign markets as distant as Tahiti as early as 1883. The founders were French immigrant Germain Crochat, Charles Volper from Switzerland, and Fred Metzner, a German-Swiss. I am told that no wines were made there after 1894, and that the buildings later housed a perlite plant.

43

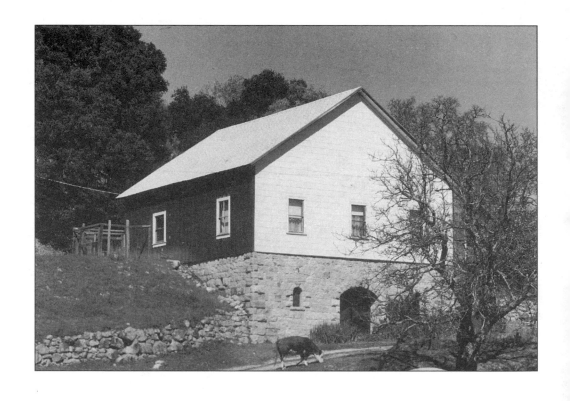

Greenfield Road leads north from Conn Valley Road to a two-story pre-Prohibition stone and wood cellar, now a residence, opposite the Buehler Vineyards. It once was owned by a member of the Salmina family, who operated the Larkmead winery, now occupied by Hanns Kornell.

No trace remains of two more wineries that operated in Conn Valley before Prohibition. One was the cellar of a Frenchman named Corthay, below the present Glendale Ranch. The other was the Glendale Cellar, built in 1887 by J. E. Hall.

44

Howell Mountain

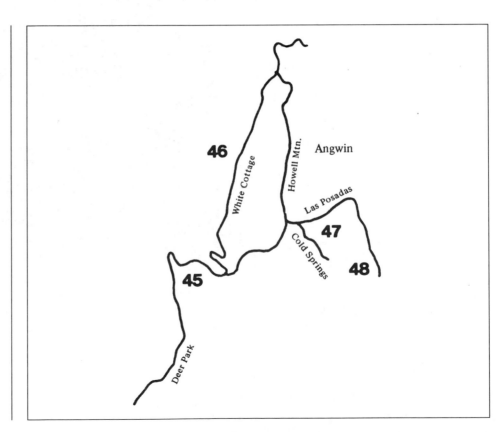

White Cottage

Howell Mtn.

Angwin

Las Posadas

Cold Springs

Deer Park

46

45

47

48

Chapter 6

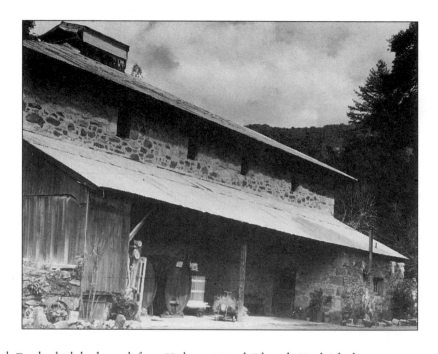

The usual route up Howell Mountain is via Deer Park Road, which leads north from Highway 29 and Silverado Trail. The big two-story stone Deer Park Winery, one of the oldest on Howell Mountain, is on your right where Sanatorium Road dead-ends at Deer Park Road. It bears the number "1000." It was twice a ghost and came to life again in 1979. Its founding date is not recorded, but the cellar was built not long after the mid-19th century by John and Jacob Sutter, cousins of Captain John Sutter of Sutter's Fort and gold rush fame. How long it stood idle when they left is also not clear, but John Ballentine from Ireland bought the place in 1920, kept it closed during Prohibition, then made bulk wine there from Repeal until 1959, when it closed again for twenty more years. It is now owned and operated as a partnership by David and Kinta Clark and Robert and Lila Knapp.

45

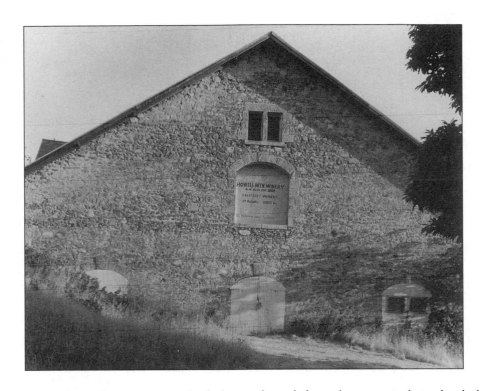

St. Helena Star
October 15, 1886

*Brun and Chaix...
completed the erection of
one of the most convenient
and commodious wine
cellars in the Country
with storage up to
150,000 gallons.*

On winding White Cottage Road, which extends north from where Deer Park Road ends, keep a sharp lookout to your left to find the Howell Mountain Winery, a three-story stone cellar nestled behind a knoll. It was built in 1886 by French emigrés Jean Adolphe Brun and Jean Chaix, who named it Howell Mountain Winery. In 1877 they had built a winery on the floor of the valley at Oakville and named it Nouveau Medoc Vineyards. Later owners closed the Howell Mountain Winery during Prohibition but bulk wine was made there sporadically until 1946. The winery is now owned and operated by Francis and Francoise Woltner who have renamed it Chateau Woltner.

46

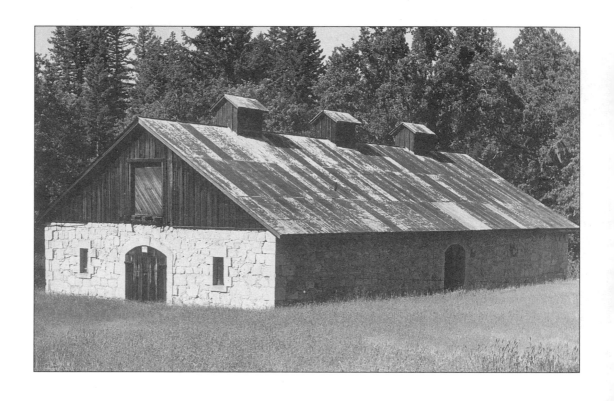

To see the two other ghost wineries on the mountain, take College Avenue southwest to Howell Mountain Road, from which Cold Springs Road extends east to Las Posadas Road. There you find the one-story stone cellar named "Liparita," built in 1880 by W. F. Keyes, the son of the General Keyes who owned the Edge Hill winery west of St. Helena, mentioned earlier. Records of the American wines entered in the Paris Exposition of 1900 list the Liparita Vineyards as having won a gold and a bronze medal in the historic competition.

47

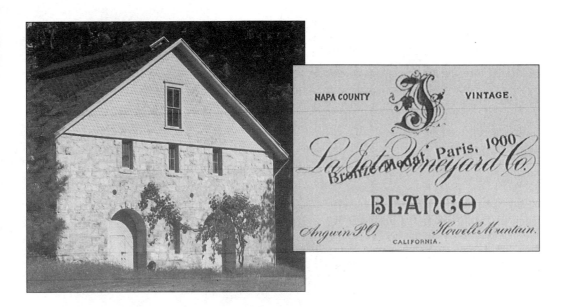

Continue east two miles on Las Posadas Road. There, a few hundred yards beyond a gate at the right, is the handsome stone LaJota ("the J" in Spanish, named for the land grant) winery, built in 1898 by Frederick Hess from Locarno in Switzerland, who owned a German-language newspaper in San Francisco. Native stone quarried on the property was used to build the 26-inch-thick walls. Oil-lease specialist William H. Smith of Aptos, a home-winemaker, now owns the La Jota cellar and has replanted its vineyards and reactivated the winery. One of his treasures is the label of the La Jota Blanco (white) wine which won a bronze metal at the Paris Exposition in 1900. (The "Liparita-La Jota" label pictured with the Liparita ghost cellar is evidence that it was a La Jota red wine that won the gold metal in Paris; apparently both of the wineries were operated together at the time.)

There once was another famous winery on the south slope of Howell Mountain. It was built of wood and stone in 1885 by George Mee (nee McMee), who named it the Spring Hill Winery. It lasted until the early 1900s, when Mee's vineyards began dying of phylloxera.

48

St. Helena to Yountville

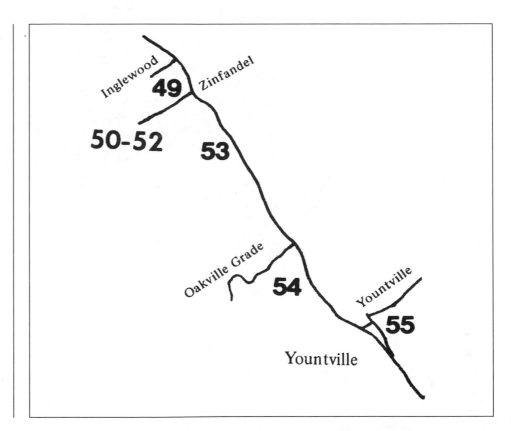

Inglewood
Zinfandel
49
50-52
53
Oakville Grade
54
Yountville
55
Yountville

Chapter 7

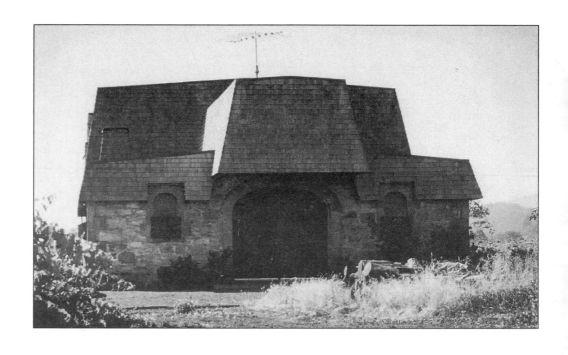

South of St. Helena, there are ghost wineries both east and west of Highway 29. On Inglewood Avenue, a half mile west of the highway, there is a stone residence that was once a winery. Captain Thomas Amesbury built it in 1886 and operated it for several years. Loss of his grape crops, presumably to phylloxera, left his winery idle for a time. Marco Calari made wine there in 1915-16 and apparently closed the cellar shortly before the Volstead Act became law in 1920. The building retains little of its appearance as a winery except its arched windows and doors.

49

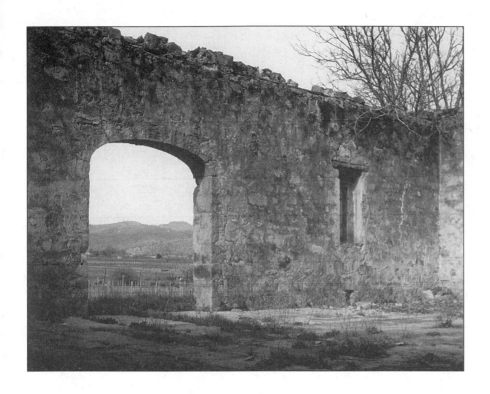

From the west end of Zinfandel Lane, if you look southward, you see against the hill a stone wall that has withstood earthquakes for almost a century. It is all that remains of the once-great wine cellars of H. W. Helms, a viticulturist from Germany, who built his winery in 1883.

50

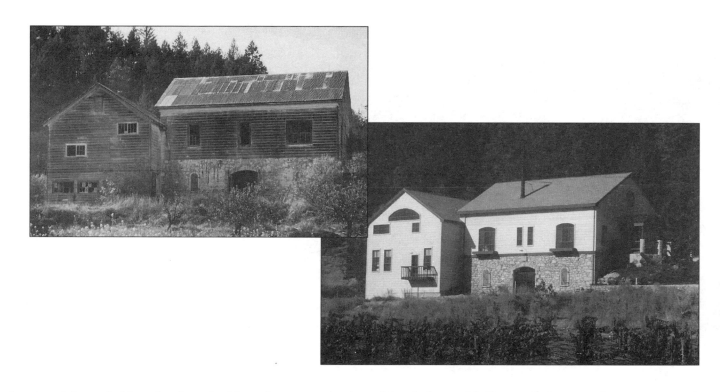

One of the two buildings directly north of the Helms ruins is the ghost of the Charles Brockhoff winery, built in 1885 by a countryman of Helms. Brockhoff's sons, Charles and Emil, made wine there for many years. Closed by Prohibition, the cellar remained empty until Louis M. Martini came on a visit to St. Helena from Kingsburg during the 1930s and purchased this and a neighboring ghost winery, Flora-Rennie. In 1940 Martini moved with his family to St. Helena. After Martini's death in 1974, Bechtel Corporation President Jerome Komes purchased both of the buildings. The one-time Brockhoff winery has been converted into a handsome home by John and Carri Komes.

51

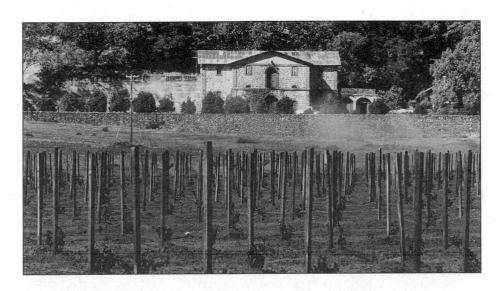

The neighboring building on the north of the Brockhoff place was originally the Rennie Brothers winery, built in the early 1880s by James and William Rennie from Scotland. The Rennies sold their winery in 1888 and moved to Fresno where they became associated with the Barton Estate winery. It was a time when port and sherry demand was growing faster than the demand for fine table wine. It was in the Rennie cellar that Martini amassed his secret stock of Napa and Sonoma fine table wines, which he introduced in 1940. Now the ancient Rennie cellar has entered a new life because Komes's daughter and son-in-law started producing wine there in 1979 as the "Flora Springs Wine Company."

Some of the finest Napa wineries of a century ago stood in this locality. At the end of Whitehall Lane was where Henry Lange from Germany founded his Olive Hill Vineyard and Winery, but nothing remains to mark the site. He was also the owner of St. Helena's Grand Hotel, which stood on Main Street near Pope. At the northeast corner of Zinfandel Lane and Highway 29 was the winery built by Charles Wheeler, a wealthy goateed Vermonter who came to the Napa Valley in 1871 at the age of 52. His sons operated the winery until Prohibition, and it was revived briefly after Repeal. The site of the Wheeler cellar is marked by the stone wall around the residence that stands on that corner.

52

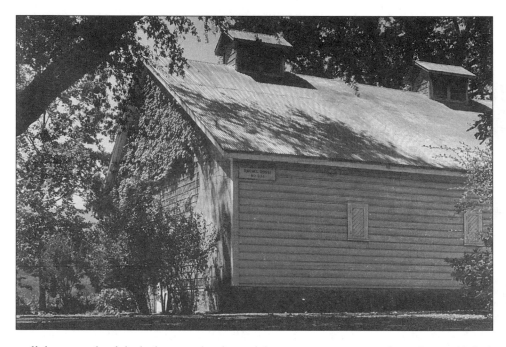

A quarter mile south of Zinfandel Lane, off the west side of the highway, is the ghost of the Norton winery, a wooden cellar established in the 1880s by one L. J. Norton. In 1907 one Fred Rossi took it over and made wine until Prohibition. It was reactivated following Repeal and crushed its last vintage in 1950.

Across the highway from Norton there once stood the Monongo Winery, established in the 1870s by Washington P. Weaks, an emigré from Ohio via Marrysville. Another noted winery, which adjoined Weak's Monongo on the east and north, was James McCord's Oak Grove Winery, whose first vintage was 1872. McCord, from New Jersey, came to Napa Valley after serving as manager of General Mariano Vallejo's farm in Sonoma. He was also a shoemaker and was remembered for the boots he made for Vallejo.

53

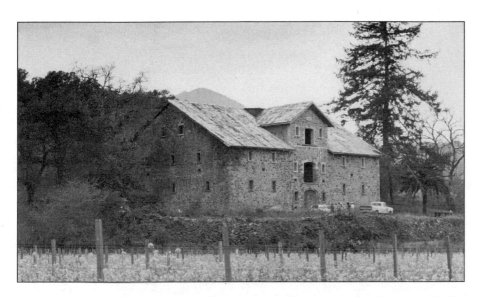

As you continue south on Highway 29, you see great three-story stone cellar atop a knoll among the vineyards west of the highway, just south of Oakville Grade Road. This was once Captain John Benson's Far Niente Winery, which is variously dated as either 1876 or 1885. Captain Benson, a New Yorker, had made a fortune in San Francisco real estate when he planted vines on his 600-acre Napa ranch beginning in 1872.

One of the grapes he favored was the Muscat of Alexandria, a variety popular at Fresno in the San Joaquin Valley rather than in the cool Oakville area of Napa County. Perhaps this is why the Captain in 1873 complained (in a letter to an eastern friend) that his Napa farm was a costly plaything, that he had spent $21,000 in improvements on top of the $10,000 he had paid for the land. The label of his wine pictured a little girl sleeping in a hammock or a swing, with the caption "without a care." The Italian saying was Dolce Far Niente, it is pleasant to do nothing. "Far Niente" is carved in stone over an upper window. Gil Nickel, who now owns Far Niente Winery, has reactivated the massive old cellar/once again it is an important part of Napa Valley wine world.

54

St. Helena Star
November 30, 1877

Mr. Crabb is not any old manufacturer, but one of the most observing and intelligent of the class who have made the chemistry of wine in all its subtle transformations a study, and applied to its elucidation the crucible of the active and highly cultured mind.

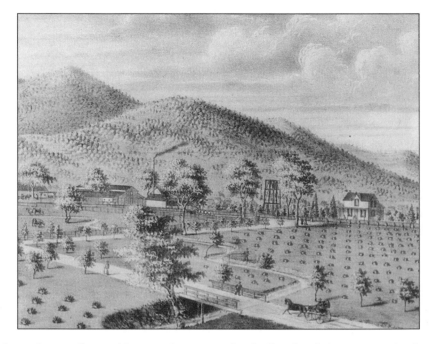

Other famous wineries nearby a century ago included Hamilton Walker Crabb's To Kalon Vineyard and cellar, founded in 1874. It faced Walnut Drive, which is now a private road opposite the village of Oakville. To Kalon means in Greek, the highest beauty, or the highest good. Contiguous to To Kalon on the north stood the Napa winery of the distinguished California Chief Justice Serranus Clinton Hastings, for whom the Hastings College of Law is named. Yet another famous early Napa winery stood at the southwest corner of Walnut Drive and the highway until it was torn down in 1941. It was John Sehabiague's Palm Row Winery, built around the turn of the century. Another early day cellar that I can locate was that of Auguste Jeanmonod, built in 1876 adjoining the Oakville winery and Brun and Chaix. These are now gone.

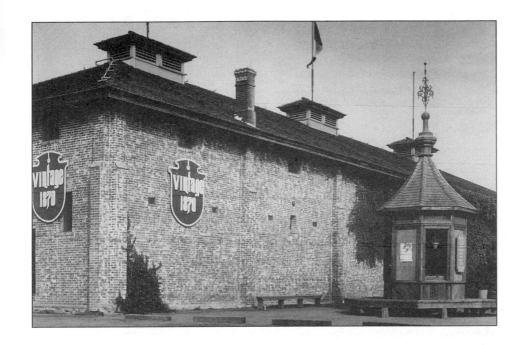

St. Helena Star
October 23, 1883

Winemaking at Groezinger's is going on finely, there are some splendid wines, including a port already on hand.

In Yountville, the ghost of the Gottlieb Groezinger winery boldly announces its founding date on the "Vintage 1870" signs that face the highway. It is the liveliest ghost in Napa County, transformed into tourist complex with restaurants, a theater, and dozens of shops which sell a complete assortment of what tourists buy, including Napa wines. Gottlieb Groezinger, from Wurttemburg via Switzerland via New York, cultivated 600 acres of vineyard around his winery until the turn of the century. The winery stood idle during Prohibition, was reactivated for a few seasons during World War II, and was idle again for almost twenty years. During the 1960s, when millions of people began visiting Napa wineries, the old winery was converted into a tourist shopping center.

55

St. Helena Star

October 23, 1884

Among the ten or a dozen cellars added this year to the winemaking capacity of the upper valley, is that of Judge S. Clinton Hastings, between Rutherford and Oakville. Built of wood and of moderate height, it is not pretentious in appearance, but is exceedingly well constructed and has many points of excellence that deserve especial notice. First of these in distinctiveness is the build of its walls, which consist of two thicknesses of wood, one without and one within, with six inches of concrete between, by which it is claimed a more equable temperature is preserved than with either stone or wood alone. Its mechanical part is very neat and compact, consisting of one of Heald's crushers and elevators, driven by horse power. This is selected as faster than hand work, being capable of forty tons a day, and cheaper than steam. Two strong horses do the work, serving one at a time and returning at half-day intervals. Water is furnished from a seven-foot well run down 27 feet, and raised by one of Bachelder's best windmills, in default of wind for which the horse power is attached.

Napa and Vicinity

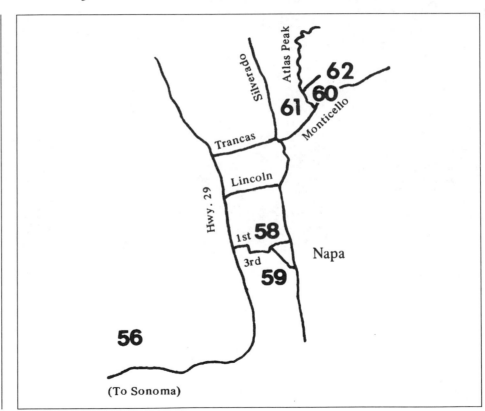

Silverado

Atlas Peak

62

60

61

Monticello

Trancas

Lincoln

Hwy. 29

1st **58**

3rd

Napa

59

56

(To Sonoma)

Chapter 8

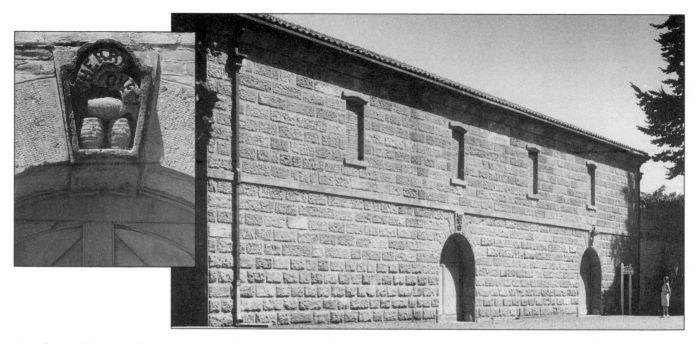

In and around the town of Napa are several ghost wineries, including one mystery ghost. The biggest, best-known, and handsomest ghost is the J. Mathews or Lisbon Cellar, a historical monument on Yount Street between Main and Brown. Carved in stone in the keystone of an arch at the right are the words "Sherry Oven," marking where Mathews baked his sherry or madeira wines. Portuguese stonemason Jose Antonio Mateus completed the massive two-story building in 1878 and gave it his anglicized name. Rudolf Jordan's Repsold Company was the next owner, but it remained closed during Prohibition. Lee and John Carbone reopened the winery briefly in the 1930s, and a subsequent owner aged wines there for several years. The same group of investors who restored the winery, in the early 1980s, added a wine shop, restaurant, seafood bar and a bed and breakfast inn, to the enclave. Bankruptcy ended the short life of the venture.

58

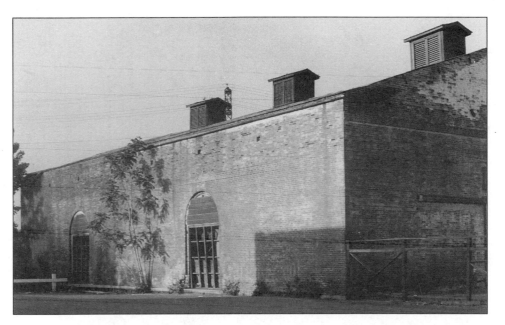

Before Prohibition there were several great cellars along the city's riverfront, where Napa wines in barrels were transported in steamers and sailing vessels to San Francisco and thence to the East Coast. The ghost of only one remains; the brick structure on the river between Brown and Main Streets was the winery of C. Carpy & Sons and dates from before 1885. After standing for more than a century the venerable building was torn down. Its neighbors included the Uncle Sam Winery, which stood at Fourth and Main Streets, and the Napa Valley Wine Company cellar, which faced the river below Fifth Street. At Monroe and First Streets was the stone winery that John Patchett from England built to replace an adobe cellar he had first erected in 1859. The city-county library block bounded by Fifth, Division, and Coombs Streets was occupied by the great winery of Italian immigrant Giuseppe Migliavaca, who was succeeded by his sons Joseph, James, and Lawrence.

59

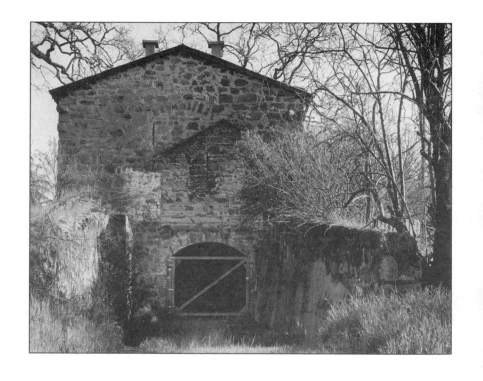

A ghost winery outside the city is the stone LePori or "A.S." cellar on Hillcrest Drive, just off Atlas Peak Road. John LePori, a Swiss-born San Francisco hotelman, operated it from the late 1880s until Prohibition and also bottled Napa County's Vichy Water there. Who originally built the cellar I have not been able to learn. The date "1889" is cut into stone with the initials "A.S.," which may refer to Alphonsine S. Domergue or to A. Spaulding, who were mentioned in a foreclosure proceeding in 1891. This building was demolished in the early 1990s.

60

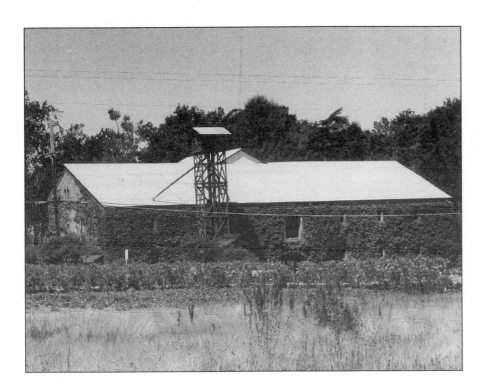

Another ghost on the west side of Atlas Peak Road opposite Hillcrest is the vine-covered stone Hedgeside winery and distillery, built in 1885 by Morris M. Estee from Pennsylvania, who became a lawyer, member of the California Legislature, author of a famous set of lawbooks, and organizer of the Napa Vinicultural Society. Closed by Prohibition, Hedgeside was reopened at Repeal as a distillery, then produced alcohol for the government during World War II. Its vinous life ended in 1950.

Nothing remains of the once-great cellar of Henry Hagen from Germany, which was built in 1877 on the left side of Hagen Road.

61

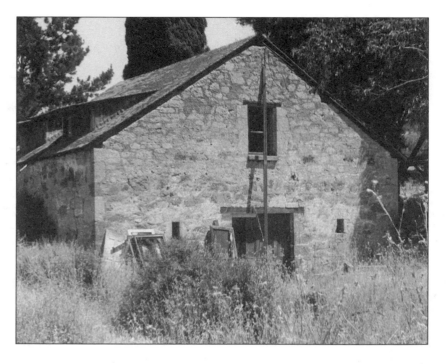

On Monticello Road, at your left a half mile past Vichy Avenue, is the anonymous mystery ghost, a two-story stone cellar surrounded by weeds, for whose identity and history I have searched fruitlessly for the past ten years. Nobody has yet been able to give me a clue.

Relics of the early days of Napa wine are not so easily found along the highway leading south from Napa. One is the road sign you see in the Carneros district, on the east side of 121; Stanly Lane. It commemorates Judge John Stanly's La Loma Vineyard (not connected with a present winery of that name), which grew prize-winning Napa wines before Prohibition. It was reactivated after Repeal and destroyed by fire in 1936. No trace remains of his winery, but his vineyard is still productive after a century.

62

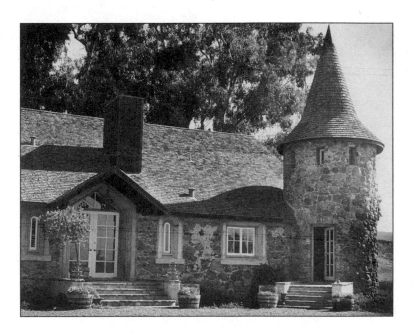

On the north side of 121 a mile east of the Sonoma County line, you may glimpse a castle topped by a tower above the vineyards. It marks what was once the Talcoa Vineyard, where noted Viticulture Professor George Husmann in 1833 wrote his third book to explain why he had abandoned the University of Missouri to become a winemaker here in California, "...the true home of the grape...destined to be the vine land of the world."

An earlier winery called Huichica for the nearby creek had been built on the property in the early 1860s by Indiana trapper-explorer William Winter, who made his wine of Mission grapes. The present castle was built as a winery in 1885 by Michael Debret and Pierre Priet, winegrowers who emigrated to Napa from France. Since 1960 it has been the baronial residence of art collector Rene di Rosa, who has replanted the 125-acre vineyard with premium quality varieties.

56

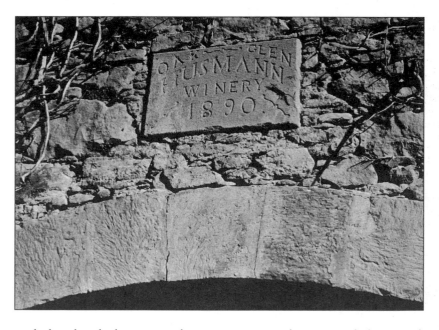

For years I faced a riddle about Professor Husmann. He had made only the vintages of 1883 to 1885 at Talcoa Vineyard, then moved to a Napa County vineyard of his own, but where that second vineyard was I could not learn. Husmann dated each of his books with the name of the vineyard where it was written: Talcoa in 1833, and his last book, dated October 20, 1887 (Grape Culture and Wine-Making in California), bore the name, "Oak Glen Vineyard." Where was the Oak Glen Vineyard?

I am indebted to Mr. and Mrs. Louis P. Martini for locating Oak Glen. In the 1960s, the Martinis had bought land in Chiles Valley, high in the hills east of St. Helena, on which to plant a vineyard. On the land they found ruins of a stone ghost winery, its facade still standing, with this legend carved in the keystone above the door: "Oak Glen - Husmann Winery - 1890." The ruins were removed, but the keystone is preserved at the Martinis' home.

The Western Hills

During the late nineteenth century there were scores of wineries on slopes and crests of the mountains west of the Napa Valley. It was natural for the German and French emigrés to choose hilly locations for their vineyards, similar to those in their homelands. Many of the ruins of such mountain wineries have not yet been identified.

Two of the best-known mountain ghost wineries that were restored to activity following Repeal are on Mount Veeder: the three-story stone cellar on The Christian Brothers' Mount La Salle Vineyards above Redwood Road and the present Mayacamas Vineyard winery on Lokoya Road off Mount Veeder Road. It was 1903 when Oakland vintner Theodore Gier built the ancient winery at Mount La Salle, and it replaced an earlier winery built by one H. Hudemann about 1864. Gier named the place "Sequoia," and the stone gates with their legend "Sequoia Vineyard" beneath the new Christian Brothers' sign are still preserved. The three-story Mayacamas cellar was built by John Henry Fischer from Stuttgart in 1889.

Chapter 9

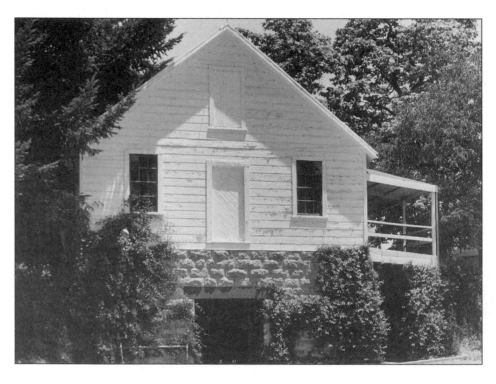

Another ghost on Mount Veeder is on the south side of Redwood Road, a fraction of a mile east of the turnoff to Mont La Salle. It once was the Castle Rock Winery, appropriately named for the massive rock that rises hundreds of feet west of the wood and stone building. Nicholas Streich, a winegrower from Germany, built his winery in 1880, and Castle Rock wines were favorites in Chicago before Prohibition, when Streich's son Ernest was the winemaker. Nothing remains of another famous pre-Prohibition winery in the vicinity, the cellar of German immigrant George Barth, built in the 1870s.

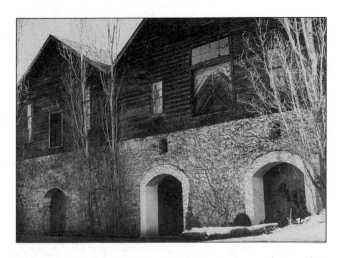

The ghosts on Spring Mountain, sixteen miles northwest of Mount Veeder, are reached from St. Helena via Spring Mountain Road. A private road two miles uphill from St. Helena's Main Street leads left up the moutainside to the great Draper or La Perla Vineyards and to the handsome wood and stone La Perla cellar on the mountaintop. Permission is required to travel the road. The La Perla cellar was built in the 1870s by Charles Lemme from Germany and later was owned by Claus Schilling of the San Francisco family of dealers in wine, spice, coffee, and tea. The cellar is now owned by Jerome Draper, who has replanted the vineyard.

A third famous winery on Spring Mountain is Chateau Chevalier, with its twin steeples and stained-glass windows, built in 1891 by San Francisco wine merchant George Chevalier. It was a ghost before Prohibition and remained empty until Gregory and Kathy Bissonette began replanting the vineyard and moved into the cellar with the six children in 1971.

Mount Diamond, north of St. Helena, has three historic wineries, two of which are producing wine again. Schramsberg Road leads north and west from Highway 29 to the two wineries of which Robert Louis Stevenson wrote in his Silverado Squatters, describing his honeymoon visit to Napa County in 1880. One is the wood and stone Alta Vineyard winery, built in 1878 by Scottish immigrant and master mariner Colin T. McEachran and revived in 1980 by Benjamin and Rose Falk and their son Ben.

64

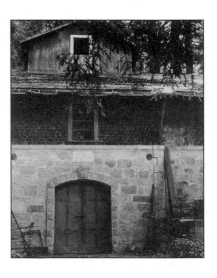

The other, which faces the Alta cellar, is famous Schramsberg Champagne Cellars with its marvelous tunnels, described by RLS as "dug into the hillside like a bandit's cave." Founded in 1862 by the itinerant German barber Jacob Schram and his wife Annie, the cellar and tunnels were idle and empty during Prohibition and are now owned by Jack and James Davies, who have made its wine world famous.

Diamond Mountain Road, about two miles north of the road to Schramsberg and Alta, leads toward a ghost winery that may be rather hard to find. About 1.1 mile uphill from the highway, there is a dead-end paved road to the right, once known as Pachetueau Lane. It terminates at clump of buildings, from which a dirt road circles the hillside. Built into the hill, a short distance from the building, is a venerable winery of wood, brick, and stone. Above the door is a plaque carved in stone, with the date "1888" and a monogram "RS." For many years the identity of this ghost cellar was a local mystery, including to the owner of the neighboring Diamond Creek Vineyard, who stored wine there during the 1970s. Research has now established that the winery's original name was Schmidt. In recent years the ghost and surrounding land have become the property of Sterling Vineyards, which has planted new vineyards west of the Schmidt winery ghost but has not reactivated the winery.

65

NAPA WINE
A History from Mission Days to Present

CHARLES L. SULLIVAN
ILLUSTRATIONS BY
EARL THOLLANDER

With Original 1889 Hand-tinted Photographs from Napa Valley Wine Library and 180 Historic Photos in Duotone

This is the first authoritative and comprehensive history of Napa Valley wine growing. The book is based on more than seven years of research of original resources and historic materials. The author has visited every historic sight and talked with every living history resource as well as dug into the original documents and periodicals. Published in cooperation with The Napa Valley Wine Library, every attention to scholarly detail has been given. The modern wine lover will appreciate the connection between the original vineyards and today's great wine producers. Fascinating reading for any wine afficionado or history buff. Hardbound, 438 pages, 20 page index, Historic Maps, Charts of Vineyard Ownership and Vintages from 1880s to present. $29.95 ISBN 0-932664-70-9

There is also available a Special Leather-bound, signed and numbered Collectors Edition. Limited to 500 copies only.

Please send me _____ copies of Napa Wine @ $29.95 $ _____
_____ copies of Special Leather-bound Ltd. Ed. @ $85.00 $ _____
One Shipping Charge of $4.00 per destination $ _____
(California Destination) 7 1/2% Sales Tax $ _____
Total Charged or Enclosed $ _____ .

Order by phone: 800-231-9463 FAX: 415-864-0377
By Mail: Wine Appreciation Guild
155 Connecticut Street, San Francisco, CA 94107

Ship to: _____

Credit Card Orders: ___MC ___VISA ___AMEX

Card # _____ Exp Date: _____

Signature _____

Acknowledgments & Notes

I am indebted to hundreds of friends whose generous help during the past ten years has made it possible for this book to be researched and written. Most of all, during the past year, I am indebted to Leon D. Adams of Sausalito, who encouraged me to complete the book and to adopt its present order which makes it convenient for the reader to find the winery ghosts. His generous help is explained, he says, by the fact that my book is a detailed extension of his own description of Napa Valley and its winegrowing history in his monumental The Wines of America, second edition 1978.

The heirs and descendants of our early Napa winegrowers have been exceptionally patient in answering my hundreds of questions about their forebears. Many of them have traveled the wine roads with me, helping to locate the old cellars. One whose assistance in this regard and also in planning my text is Michael Dow, who teaches creative writing in Napa and Sonoma counties. Especially I wish to acknowledge the help of Norma Vasconi and her late husband Judge Louis Vasconi, with their great knowledge of old Napa County families and their wineries.

Esther Waite was the first to suggest that my photographs be published as a contribution to Napa wine history. Encouraging and helping me, too, were M.F.K. Fisher, James Beard, Gunther Detert, my son Duncan Haynes, and his wife Patricia. Warren Young, with his great knowledge of photography, is responsible for whatever quality some of my prints may have, and it was he who produced the Vine Cliff winery photo from a small print kindly given by John Wichels.

For their invaluable help in the geographic sections of the book, I wish to thank:

In the St. Helena area, Rena (Mrs. Fred) Beroldo, Everett Bellani, Louis Bettini, Albert Butala, Kenneth S. Cairns II, Gladys Graff, William and Claire Giugni, Emma (Mrs. Carl) Hilker, William Jaeger, Ina (Mrs. William) Hart, Benjamin and Constance Skillings, John R. Stanton, Louis Paulson, Mario Vasconi, Marietta Voorhees, Alice (Mrs. Alexander) Riach, Rudolph Rossi, Robert Pecota, John Poggi, Luigi and Irma Quaglia, Gladys and John Wichels, Fred Abruzzini, T. J. Laurent, Sr., Mrs. Grant Ellis, Alice and the late William Gonser, Lois Alexander Gifford, Josephine Varozza (Mrs. Parker J.) Barfield, Bob and Evelyn Trinchero, F. Bourn and Nell Hayne.

From Ehlers Lane North, W. W. "Jack" Lyman, Buck Erickson, Hanns and Marilouise Kornell, Anna (Mrs. Frank) Pocai, and Olivia (Mrs. Frederick) Heitz, Betty Ballentine.

About the ghosts around Calistoga, Joyce (Mrs. Jules) Alcouffe, Kay(Mrs. V. W.) Archuleta, Frank Barberis, Joseph and Elva Bettini, Teckla (Mrs. Cyril) Bott, Kathryn (Mrs. Ivan) Boyadjieff, Orpha Doda (Mrs. Lawrence) Brayton, Jane (Mrs. Kenneth) Campbell, Will and Patricia Drew, Duane and Kathryn Russell, Jeanne (Mrs. Eugene) Frediani, Louis W. Gerhardt, Ella (Mrs. Luther) Light, Donna (Mrs. Frank) McGreane, Leila Crouch, Milton and Ruth

Sherwood, Wade Mills, Pete and Grace Molinari, Charles Nolasco, Monie M. (Mrs. Walter E.) Tamagni, Mabel (Mrs. C. L.) Petersen, Paul and Hortense McComish, Louise Shonts, Earl Thollander, Carolyn (Mrs. Henry) Turner, J. Bernard Seps, Alfred Frediani, Milton Eisele, Marie R. Rogers, Edith Baptie, Mary (Mrs. Lionel) Saviez, John and Mary Rolleri, John and Edy Wilkinson, Bess (Mrs. John B.) Ghisolofo, Marie (Mrs. Andrew) Luvisi, Thelma Tamagni, Milton and Vera Petersen, and Yolanda Toschi.

Along Silverado Trail from Calistoga, Lilly Rossini, Suzanne B. (Mrs. Warren) Lemmon, Mr. and Mrs. William McPherson, Jose Cebrian, Charles Carpy, Thomas Parker, Mrs. Silvio Tonascia, David Lercari, Warren and Barbara Winiarski, Andrew Fagiani, Captain W. C. Mackey, John Soracco, Edward Dellagana, Mr. William Buehler.

About the ghost wineries of Conn Valley, Arthur L. Wilcox, David Fasken, Hazel Metzner, Alice (Mrs. Kenneth) Taplin, Mili Zopfi, Ellen (Mrs. Francis Wayne) MacVeagh, T. Anthony Quinn of Sacramento, Adelaide (Mrs. Elmer) Salmina, Eugene B. Morosoli of Alameda, Silvio Pelandini, Helene Thompson, Elsie Hudak, Peggy Miami, Marie Volper, Pauline Marty.

Concerning the Howell Mountain ghosts, W. V. Ballentine, Lorraine Kirkpatrick, David and Kinta Clark, William H. and Joan Smith, Elwood Mee, Walter Schug.

From St. Helena south to Rutherford, Charles Brockhoff of Woodland, Mrs. August Brockhoff of Napa, Eleanor (Mrs. Ed) Voorhees, Patsy (Mrs. Robert) Wood, John and Carri Komes, Patrick and Julie Garvey, James Lider, Louise Rossi.

From Rutherford past Yountville, Ivan and Barbara Schoch, Gil and John Nickel, Arthur Schmidt, Marie del Bondio, Jean (Mrs. W. E.) van Loben Sells, Catherine (Mrs. Fred J.) Lerner.

About Napa and vicinity, Louis Ezettie, who generously shared his vast knowledge of Napa County history, Fred Pond, Jess Doud, Eugene Chopping, Judge Wade Shifflet, Jr., Mrs. Melvin Lauritsen, Mrs. Julius Le Pori, Mrs. Gordon H. Smith, Napa County Assessor George Abate, the staff of the Recorder's Office, Ron Abruzzini, Mrs. J Garetto.

Concerning the ghosts on the western hills, Robert and Elinor Travers, Jerome Draper, Gregory and Kathy Bissonette, Jack and Jamie Davies, Benjamin and Rose Falk, Gene Hill, and Albert and Boots Brounstein.

The best single source of records and books proved to be the Napa Valley Wine Library Association collection kept at the St. Helena Public Library. My warm thanks to its director, Clayla Davis, to staff members Barbara Kaiser and Mildred De Jager, and especially to Elizabeth Reed, the former St. Helena publican librarian. June Inghram at the Calistoga Library has also been most helpful. Like all books containing Napa history, this one owes much of its material to the St. Helena's Great Newspaper The Star, which has recorded the progress of winegrowing throughout the county continuously since 1874. The Napa Register and The Weekly Calistogan have also been drawn upon for information.

Irene W. Haynes

Index